CART-RUTS
and their impact on the Maltese landscape

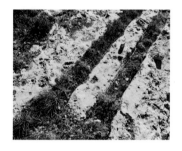

DAVID H. TRUMP

PHOTOGRAPHY
DANIEL CILIA

HERITAGE BOOKS
2008

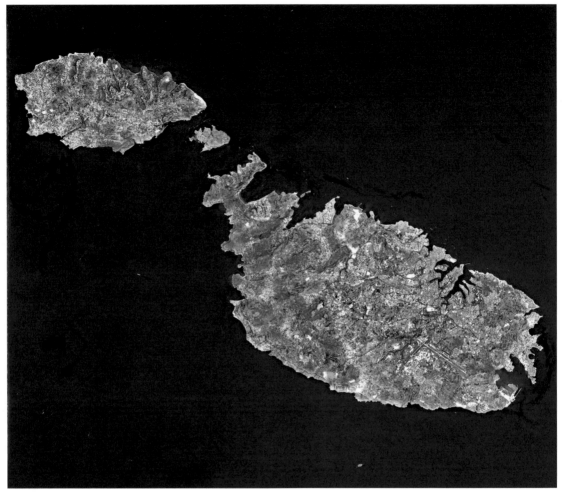

The distribution of cart-ruts in Malta and Gozo

Insight Heritage Guides Series No: 19
General Editor: Louis J. Scerri

Published by Heritage Books, a subsidiary of
Midsea Books Ltd, Carmelites Street,
Sta Venera SVR 1724, Malta
sales@midseabooks.com

*Insight Heritage Guides is a series of books intended
to give an insight into aspects and sites of Malta's
rich heritage, culture, and traditions.*

Produced by Mizzi Design & Graphic Services
Printed by Gutenberg Press

This series is supported by:

MALTA TOURISM AUTHORITY

First published 2008

ISBN: 978-99932-7-209-0

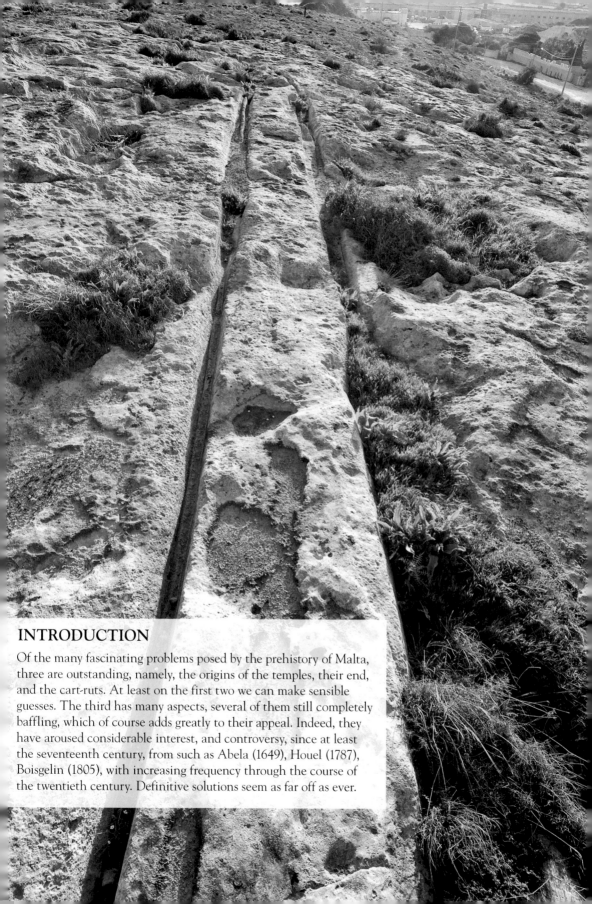

INTRODUCTION

Of the many fascinating problems posed by the prehistory of Malta, three are outstanding, namely, the origins of the temples, their end, and the cart-ruts. At least on the first two we can make sensible guesses. The third has many aspects, several of them still completely baffling, which of course adds greatly to their appeal. Indeed, they have aroused considerable interest, and controversy, since at least the seventeenth century, from such as Abela (1649), Houel (1787), Boisgelin (1805), with increasing frequency through the course of the twentieth century. Definitive solutions seem as far off as ever.

DISTRIBUTION

The ruts themselves are widely distributed from end to end of the island group wherever rock is exposed. Outside Malta, isolated examples have been reported, usually associated with old quarries, but nowhere else do they form systems remotely as elaborate as those here. We get little help in understanding the Maltese ones by looking for parallels elsewhere, as applies also to the temples.

The ruts invariably occur in pairs, consisting of grooves of narrow V-section, though with a more or less rounded bottom some 7 cm wide. The width at the top naturally depends on the depth, which can be anything up to 60cm at one extreme, but can dwindle to nothing at the other.

The gauge, the distance between the two ruts of a pair, varies only slightly, around the average of about 1.41 m, only 3 cm less than the standard railway gauge of 4'8 ½".

A very puzzling detail which will need further consideration, is that even the gauge of an individual pair can be a couple of centimetres more or less at different points along its length. Ruts left by recent carts differ

A deep pair emerges from beneath the modern road at San Pawl tat-Tarġa, Naxxar. Note the irregular rock surface between them.

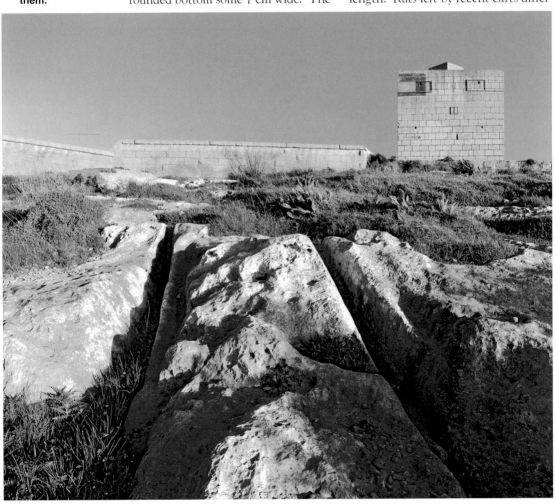

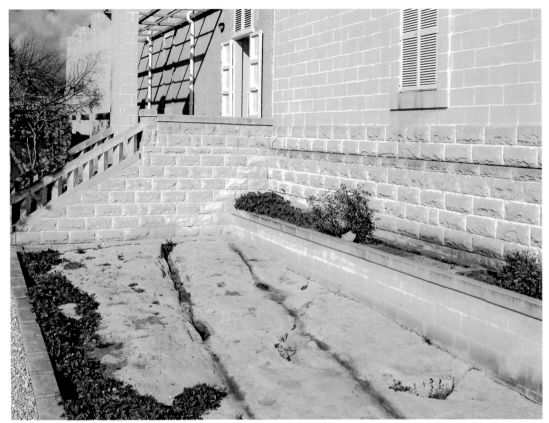

from these in two respects. They tend to be very much broader and shallower, and, unlike the ancient ones, invariably show heavy wear on the rock surface between them, left by whatever animal it was, horse, mule, donkey or ox, which drew them.

What clearly demonstrates that these ruts are indeed ancient, is that the modern landscape pattern takes no notice of them whatsoever. The only exceptions to this are where particular pairs have been deliberately spared from later over-building, as at San Ġwann, Mtarfa and the Ġhar Dalam Museum garden. Otherwise, they are ignored, covered in field soil, overlain by stone walls, roads, buildings, or simply quarried away. Indeed, in the last case, some old quarries used the grooves of earlier ruts as part of their slots for detach-

ing blocks. Another similar example is where rainwater run-off, trapped by a rut, has been channelled into a patently more recent cistern.

Paradoxically, though the countryside has been completely re-ordered since the ruts went out of use, it is frequently apparent that the present roads and lanes are doing the same thing as the ruts had done long before, on closely similar, though never exactly the same, lines. Some cross from one valley to the next, some follow a ridge, others the boundary between rocky slope and plain, skirt the lip of a cliff or negotiate a steep slope by means of hairpin bends. In each of these cases, modern roads can be found behaving in a very similar way, often immediately adjacent.

While their general behaviour thus seems very sensible, there are several

A pair of ruts was discovered when a new wing was added to the Ġhar Dalam Museum.

details much less so, quite apart from the incredible complexity of far and away the most complex group, appropriately nicknamed Clapham Junction. The first of these, their sheer depth, has already been noted. More remarkable is that several cases are known where one rut of a pair, having worn into a patch of softer rock, is very much deeper than the other. In three places, in the San Pawl tat-Tarġa, Ta' Tinġi and Dwejra groups, this is so marked that the inner edge of the deeper rut is slightly undercut. This must have caused an alarming lurch for the passing vehicle. Further, there are at least half a dozen examples of ruts dipping, if only over short distances, at an angle of 45°. This would have put an enormous strain on any cart or slide car, travelling along one of these ruts, whether up or down.

The logic of the ruts' layout, then, is the biggest argument that they were indeed the result of the movement of vehicles around the countryside. Despite this, what seems inescapable is that they were in no sense planned as a system, but developed organically, and over a long period of time. We can discount suggestions that they were designed for water catchment, or to make raised field beds. Only one researcher chose the complete, but unacceptable, let-out, that they must be the result of some unexplained, natural agency. Fortunately, though perhaps a little surprisingly, no-one has yet argued that they were landing strips for extra-terrestrial spacecraft.

So far so good. The problems and difficulties can only increase from now on.

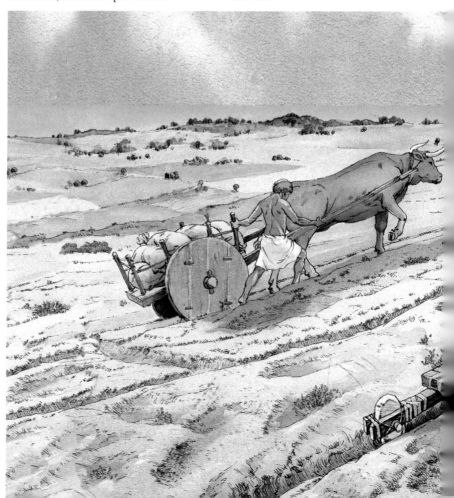

VEHICLES

The first of these is the nature of the vehicles responsible for these ruts. There would seem to be only three possibilities, sledges, slide-cars or carts. Not unnaturally, it was at first assumed that they had to be carts, despite the different shape of their grooves, noted above. Modern cart-ruts tend to be much broader and shallower. What cast considerable doubt on this was the observation, already mentioned, that a single pair of ruts had a less than consistent distance between the grooves. It was argued that this could have only one of two results: either the wheels would lock in the grooves, preventing any motion, or they would be wrenched off their axle, with even more disastrous consequences.

If wheeled vehicles were impossible, what alternatives were there?

Sledges, found in many parts of the world, were considered, but have to meet the same objection as the wheels over the varying gauge, and others also. One is that in several places ruts make quite sharp turns, such that a fixed runner would be unable to negotiate them without again either locking, or more likely splaying the rut width as it swung round the bend. This looks fairly conclusive, reinforced by the more recent observation that the bottom of a rut can ride over a ridge of harder rock, which would be equally difficult for a fixed runner. Sledges can surely be ruled out.

That leaves slide-cars, a rather awkward term, but more explanatory

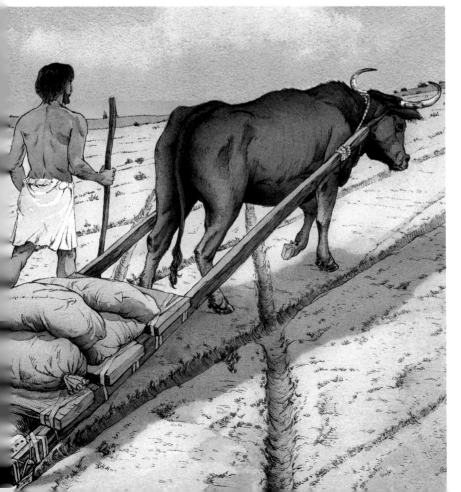

Artist's reconstruction of the two possible vehicle types, slide car and wheeled cart.

than the alternative one of 'travois'. The latter was employed for the most familiar example, where American Indians on the Great Plains, after dismantling their tipis, would make a bundle of their hide covers and other possessions, and tie it to the tipi poles. One end of the latter would be attached to their mustang while the other dragged along the ground. Though this would leave a very slight and temporary scar on the grasslands of the prairies, it was argued that, over a period of time, and if care was taken in keeping to exactly the same track, these could cause just such worn grooves as we see in Malta. The advantages of doing this were obvious. Over rough rock, particularly if first marked out by tool pecking, as soon as a groove began to form, further transits would be progressively smoother and so easier.

The main objection to this is that, with the sole exception of Ireland, where a similar method was employed to bring peats out of bogs over ground

too soft for wheels to be practicable, no similar vehicles were known anywhere in Europe. Though not impossible that the Maltese could have invented the technique for themselves, neither of the special circumstances of the Great Plains or the Irish bogs applied here, making it very unlikely. Further, since the sides of the ruts are symmetrical, the splayed poles of the American Indian ones can be ruled out. Some arrangement would have to have been made whereby the poles lay parallel to each other, attached at the front to a horizontal bar.

In 1954, John Evans, in association with the BBC, carried out experiments in which it was demonstrated that a slide car would indeed work, whereas the cart posed serious difficulties as a result of that variation in gauge, but perhaps these were exaggerated, as will be suggested below. If slide cars were otherwise unknown in Europe, wheels had been available since the 4th millennium BC, when they were invented somewhere in the Near East. Within a very few centuries, their advantages were so rapidly recognized that their use had spread at least as far as the North Sea. But if they were to be responsible for the Maltese ruts, they would have to be both very large, at least 1.5m diameter, and fairly loosely attached to their axles, the former to give clearance for their axles where ruts were as

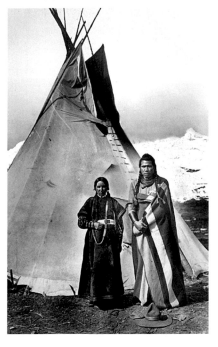

A tipi of the *Nez Percé* tribe, *c.*1900

THE CART-RUTS

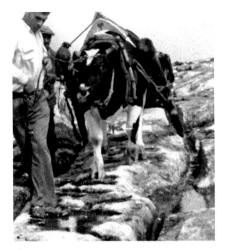

much as 60cm deep, the latter to allow for that variation in gauge. This is certainly a major difficulty.

So far then, our two main candidates for the responsible vehicle look fairly evenly matched, with a marginal preference for the slide car, at least until such time as some new evidence comes to light to tip the balance in favour of one or the other.

A problem with both these vehicles is how they could have worn such deep ruts. With both, we have to assume wooden construction, which would have taken horrendous wear against the rock, whether on wheels or runners. It is known from preserved pollen, in a silo pit at Tal Mejtin, Luqa, and in a bore hole in the Marsa basin, that trees were already scarce in Malta by the Early Bronze Age. A suggestion that runners could somehow be shod in stone is ingenious, though it is very difficult to see how this could be affected in practice. Although a new rut might have been marked out by pecking - an example at Xemxija seems to show just this - ruts were not in any sense excavated further, which would have called for great effort to no advantage. All further deepening was by wear. While it is known that the local Globigerina limestone forms a harder skin after exposure to the air, this does not apparently apply to the Coralline, so rock under a thin coating of soil would not wear more easily.

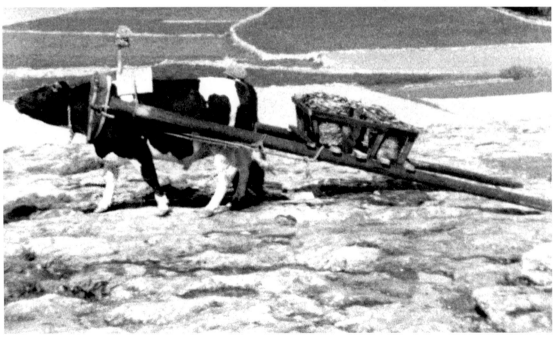

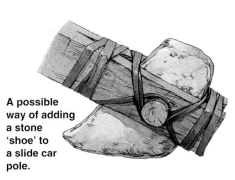

A possible way of adding a stone 'shoe' to a slide car pole.

implies long and heavy use, but whatever pulled the vehicle which produced them left no trace of its passage. With all recent ruts, the surface between them has been pounded smooth by the hooves of the horse, or whatever provided the traction. Had it been only humans, one would still have expected at least a polish from the frequent passage of even bare feet. There is no sign of such. We will shortly offer a possible explanation of what at first looks impossibly baffling.

Both varieties of limestone, however, share equally in the next problem, the extremely puzzling absence of wear between the ruts, sometimes very marked. Their depth

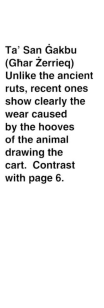

Ta' San Ġakbu (Għar Żerrieq) Unlike the ancient ruts, recent ones show clearly the wear caused by the hooves of the animal drawing the cart. Contrast with page 6.

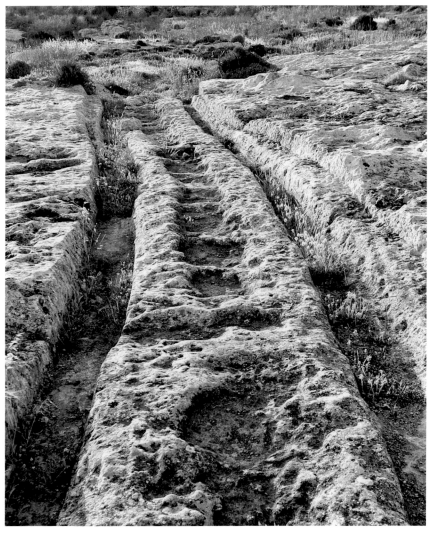

THE CART-RUTS

LOADS

The next question to ask is, what loads were carried on these vehicles? To produce that amount of wear, they were presumably heavy, frequent, over a long period of time, or all three. Many suggestions have been made.

In view of the common association with quarries elsewhere, and the fact that they are often close to quarries here, that they were for transporting stone was the first idea to occur, more particularly for carrying the large blocks required for building the Neolithic temples. However, this can be dismissed quite rapidly. Although there are examples of ruts near both temples, and quarries, none has been found to run to a temple, and only two terminate in a quarry. In the latter case, they can even be truncated by the quarrying, so patently earlier rather than contemporary. Two exceptions to this statement will be quoted below when we come to discuss the date. Further, it is difficult to see what

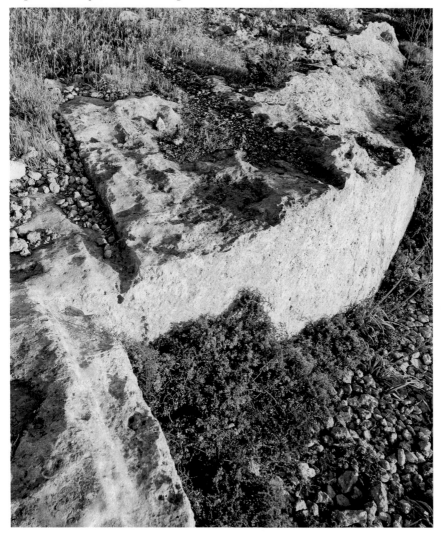

Also at Ta' San Ġakbu (Għar Żerrieq), an ancient rut has been cut away by a later quarry.

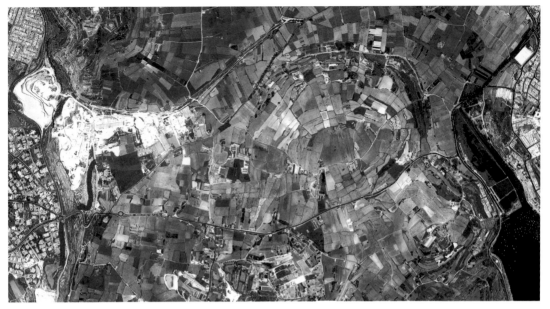

Long ruts connecting Naxxar and Salina. The deep red lines are where actual ruts are to be found, whilst the lighter red are hypothetical .

kind of vehicle could possibly have transported blocks as large as those employed in the temples. And with stone so readily available, there would be no sense in carrying it the long distances represented by some of the ruts, still less over a ridge between one cultivated valley and the next.

After erosion set in, presumably soon after the vegetation was stripped to allow cultivation, soil became comparatively scarce throughout the islands. Two arguments for moving it have been advanced. That it was moved down from the flat tops to build up terraces on the slopes can be dismissed immediately. The effort involved in constructing and maintaining terraces would be far greater than in cultivating the precious soil on the level tops. Much more convincing is the converse, that soil was brought up from the valley floors, where it accumulates to great depth, to create new fields by spreading it thinly on bare rock surfaces. Could transport of soil explain the ruts? It is certainly a possibility, but there is nothing in their distribution to support the suggestion.

The same applies with equal force to the idea that they could have served to carry water for irrigation, again to increase food production, since they do not seem to relate to water sources in any way. However, there is an additional argument against this, the impracticability of moving water in quantity when the only containers available would have been made of hides.

Unless there is some commodity to be moved around that no-one has yet thought of, that leaves only general agricultural produce. It would not have the weight of those just considered, but would have been constantly on the move from fields to settlements and between settlements, year in year out over centuries. In one case, that of the long ruts connecting Naxxar and Salina, there would have been the added factor of marine produce, like fish, salt, perhaps seaweed to manure fields. Admittedly, it is impossible to explain the multiplicity of ruts at Clapham Junction in this way, but no more so than in any other.

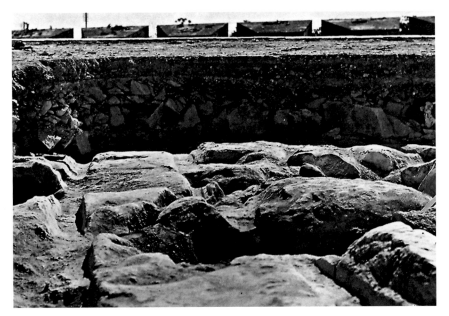

Ruts were exposed during roadworks outside the Main Gate of Valletta in the 1920s. Note the cannon embrasures at the top of the photograph.

Overleaf: This pair head towards the Bronze Age village of Wardija ta' San Ġorġ.

DESTINATIONS

Will where the ruts run from and to help place them in time? Unfortunately they all die out before reaching a clear destination. The nearest exceptions to this are at L'Imbordin, Pwales. There, one rut runs out onto a terrace which pinches out shortly beyond at a cave entrance. The latter, however, was long since emptied of any significant, dateable, contents. A second nearby appears to stop at the lip of a stable cliff. Immediately below this is another cave entrance, to which presumably any loads were lowered by rope, but this cave too is now empty.

Care must be taken to avoid reading significance into superposition. As noted above, many later buildings have been erected over, or cut through, ruts. These tell us only that the rut was not contemporary but earlier, though not by how much. The rut was not heading for this building, be it a Roman site on Qala il-Pellegrin, a bar at San Martin tal Baħrija or the main gate of Valletta,

but to somewhere beyond. The best we have is where ruts can be seen to be heading out onto promontories from which further progress is prevented by the steepness of the surrounding slopes. On a number of these there is good evidence for Bronze Age occupation, in the form of sherds and silo pits, but little if any of later periods. At three, Borġ in-Nadur, Qala Hill and Ras il-Ġebel, the last two on the Wardija Ridge, there are even more or less substantial traces of defensive walls. At none, however, can the ruts be traced right up to the line of the wall, so the evidence is no more than circumstantial.

Borġ in-Nadur also has a pair running directly towards a probable entrance in its defensive wall.

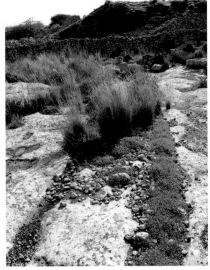

DATES

Opposite page: At San Ġakbu above the Mtaħleb valley, a pair of ruts is flaking away at the cliff lip. See also pp. 34-5.

Here again we meet wide ranging controversy. All periods from the Neolithic to that of the Knights have had their advocates, with the Bronze Age and Classical periods the most favoured. The argument that they must be of the later date, the first at which there was a central government which could organise the ruts as a country-wide system, or conversely, that central authority was established far earlier than believed, both break down when, as explained above, it seems clear that there was no such system.

No technique has yet been devised for the direct dating of the ruts. Even radiocarbon fails us completely here as it depends on the survival of organic material in intimate association. This the ruts do not have. Three natural agencies argue for some antiquity for the ruts, but none is directly datable. The pairs in St George's Bay, Birżebbuġa, and Mellieħa Bay demonstrate that between their period of use and today, sea level has risen by at least a couple of metres, though

perhaps no more. At San Ġakbu, Mtaħleb, at Qala il-Pellegrin above Ġnejna Bay, and again at Cirkewwa overlooking Paradise Bay, ruts are truncated by cliff falls. Many sites show ruts apparently fading out which, excluding the possibility that they took off into the air, must imply that they then rode up over a soil cover, now vanished. Though the last will require more consideration shortly, none of the three provides a date.

Having dismissed the carriage of megaliths, and noted the lack of association with temples - we cannot exclude Neolithic villages since so few of these have been located - that earliest period can surely be left out of account. By medieval times, one might have expected some reference to so elaborate a transport system, and greater survival into the present landscape, neither of which is found. Again, their distribution ignores the many village sites of that more recent period, known in some detail.

Rather better, though still not conclusive, is the apparent association

St George's Bay, Birżebbuġa. The sea level has risen since these ruts were in use, partially submerging them.

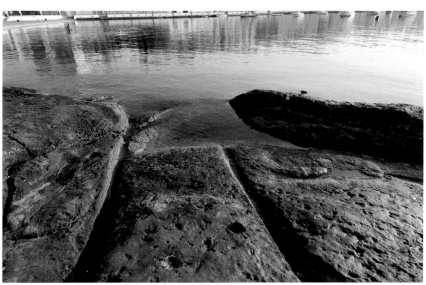

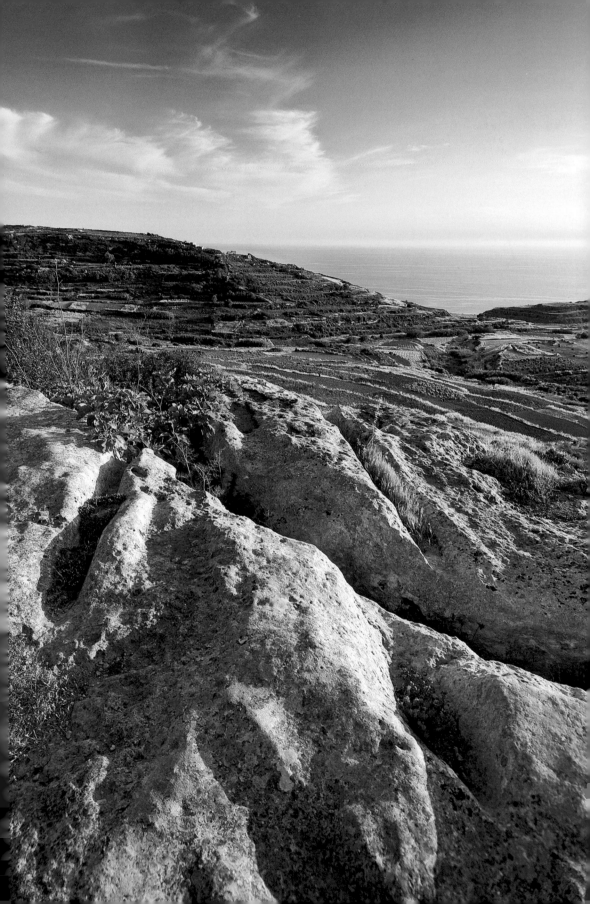

Opposite page: A pair was cut by the shaft of a Punic tomb at Mtarfa. Note the sharp edge near the left bottom corner.

of ruts with Bronze Age villages noted above, particularly the case of Borġ in-Nadur. There the rut is heading towards the point where the transverse wall turns in a little alongside the prominent projecting bastion. This seems a very likely place for an original entrance.

At a number of sites - Clapham Junction, Mtarfa, Binġemma - ruts can be observed to have been cut by the shafts of Punic tombs. The sharp edges of the cut show that unequivocally those particular ruts were earlier than those particular tomb shafts. The wording has to be chosen carefully, since it need not mean that all ruts were earlier than all such tombs, and in any case, having been found empty, the tombs themselves cannot be closely dated. They do, however, prove that the ruts started early, however late they may have continued.

We do have two examples of an association with datable sites. Within the grounds of the Roman Domus Museum, a short section of rut, of apparently identical form, runs along a length of road. Since it follows the curve of a wall of clear Roman date, at last we have one rut we can put a date on with some confidence. Again, 500 m east of Clapham Junction, on the north side of the road dropping towards Girgenti and Siġġiewi, there has been much quarrying. Most of it is of recent, medieval or modern, date, but to the north, an area shows where earlier work removed blocks of the size favoured in the Roman period. Across this, and certainly of Roman or later date, a clear pair of ruts can be made out.

However early they may have started, as suggested by the evidence from the Bronze Age villages, some at least survived into the Christian era. With some two and a half thousand years between the start of the Bronze Age and the end of the Roman period, we have ample time for a vast amount of traffic to have passed. Every loaded vehicle would have worn the rut beneath it a little deeper.

The ruts on the right curve beside a wall of Roman date in the grounds of the Domus Romana, Rabat.

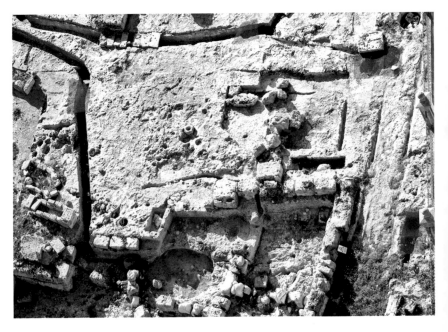

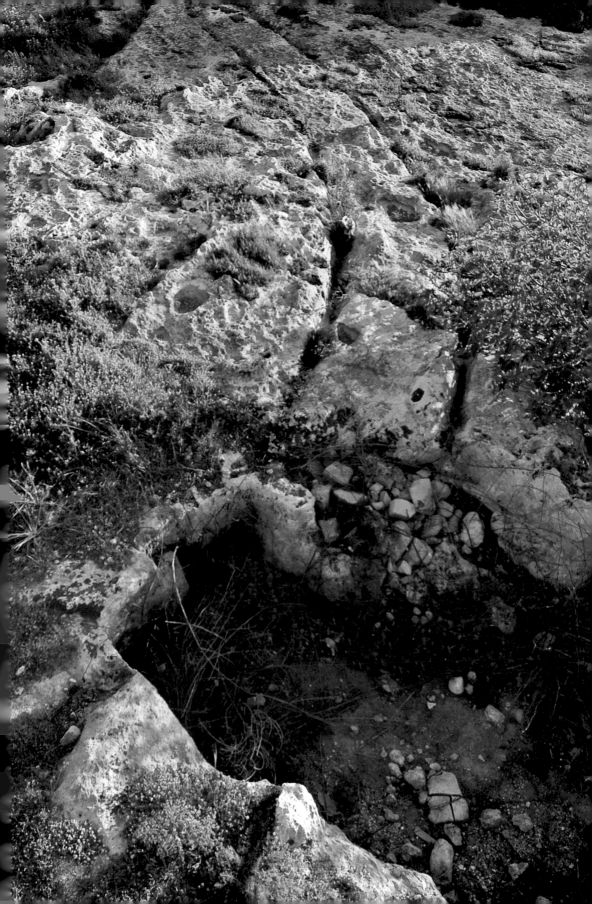

SOIL EROSION

At San Pawl tat-Tarġa, in the upper photograph, ruts swerved to avoid a dissolution hollow, whereas in the lower one, they lurched in and out of another, rounding the lip in the process.

One factor needs to be looked at in rather more detail as it can throw additional light on at least some of our problems. It has already been suggested that the way in which some ruts simply fade out on bare rock, as opposed to being covered by later deposits, can only be explained by supposing a former soil cover. There is further evidence for this. A clear example in the San Pawl tat-Tarġa group, with less obvious ones elsewhere, shows a rut riding over a natural dissolution hollow in the rock. Here, the rut has rounded off the lip of the hollow, demonstrating that, unlike with those Punic tombs, the hollow was there first. Now, anyone taking a vehicle across this could easily avoid the hollow if he had known it was there, and surely would. The implication is that it was not visible at the time, presumably masked by a thin cover of soil or vegetation. Indeed, nearby, the same rut swerves sharply to avoid another similar hollow.

A thin soil cover also offers a solution to that problem of the absence of hoof wear since it would have protected the rock surface. Further, a layer of soil, if not too thick, would also provide an abrasive agent, which would greatly speed up the wear, whatever the nature of the vehicle causing it. However, it is difficult to see how one to 5 cm of soil could have clung to those 45° steps noted above. Any greater depth would have prevented the runners from wearing the rock. It seems that whenever a gleam of light is observed, some detail can be found to cast doubt on it.

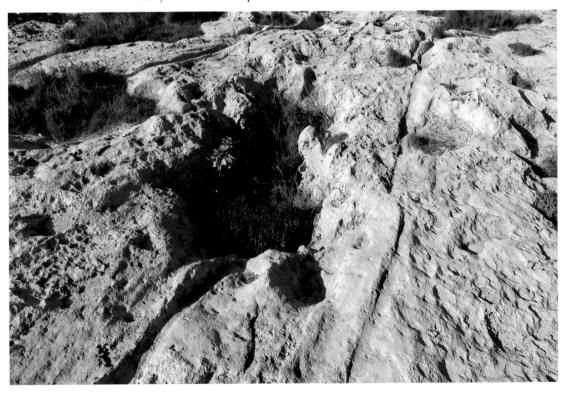

SOLUTIONS

The best directions for progress on our problems would be further survey work, at three different scales. The first would be to produce a definitive catalogue of all ruts through the two islands. Several groups of researchers are already working on this. Such lists already run to 75 or more items, though with no assurance of completeness. On the one hand, there are many cases where it is unclear whether two sets of ruts are separate, or successive lengths of a single pair or set. There must also be many which have not yet been noticed and recorded. But conversely, there are a number of which records or photographs survive whereas the ruts themselves do not.

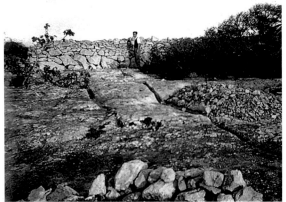

Two sets of ruts were photographed by Gravino at L-Imsaqqfa, Gudja (top) and Raħal il-Ġdid (Pawla) c.1947, both have disappeared since.

Secondly, careful mapping of some of the groups on a larger scale, as has already been done for San Pawl tat-Tarġa by Messrs Ventura and Tanti, reference below, might well yield significant new insights. Other likely groups for this treatment would be those at Binġemma, San Ġakbu, Ta' Ċenċ and Dwejra. Clapham Junction would require a great deal of time, effort and courage.

Thirdly, detailed planning in three dimensions at an even large scale of some of the more intriguing features, like lurches, swerves and steps, could throw further light.

There can be few activities as stimulating as the pursuit of cart-ruts.

On the one hand, tracing them across the Maltese countryside, watching for every little detail as to where they run next and admiring the wild flowers on the way, is surely as rewarding a physical exercise as any. But that is far from being the end of the story. There is then the mental exercise of trying to make sense of them, individually and collectively. Even if we could solve all other problems, there would remain the major one of the multiplicity of ruts at Clapham Junction. If any reader can come up with a convincing answer to that, I and many other scholars would be delighted to hear from them. However, Malta's cart-ruts would be much less exciting if we knew all the answers.

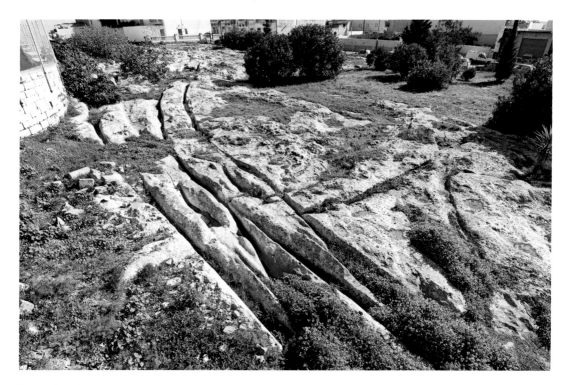

Dramatic rut junctions are visible on this bare rock at San Ġwann.

CART-RUT CATALOGUE

Categories:

A
level ground

B
up and down slope

C
ridge crest

D
side of ridge

E
crossing ridge

F
down spur

G
round spur

H
lip of cliff

I
beside or into sea

1. San Ġwann. 527745. A. A precious fragment of rut system has been preserved rather incongruously in the middle of modern housing estates. A clear pair of ruts forks into two, which rejoin soon after. This looks like a well-planned passing place, but if you look carefully, you will see that in fact one pair is at a higher level than the other, meaning that it had gone out of use earlier.

2. Kalkara. 579723. A. Clear sets of ruts cross bare rock behind the football ground.

3. Ghar Dalam. 575668. B/D. When the new room was added to the Museum above the cave, a pair of ruts was discovered immediately behind it, see p. 16. These appear to be heading down to the shore of Marsaxlokk, just as the present road does. Compare this with the Salini group, no.35.

4. St George's Bay. 576656. I. A notable pair of ruts emerges from beneath the main road, to disappear directly into the sea. This is the clearest evidence we have that the sea level here has risen relatively to the land since the ruts were in use, whenever that was, though it may be only by 2-3 metres. It was reported that in the recent past they could be seen emerging on the further side of the bay, until that area was built over. The evidence on sea level rise is corroborated by silo pits just round the corner towards Birżebbuġa, which have been similarly flooded.

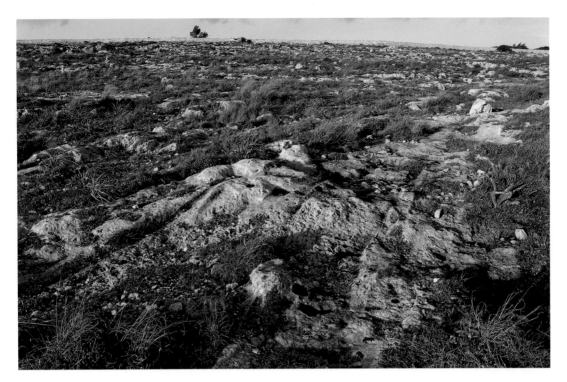

The six-digit number after each entry refers to the grid reference of the maps of Malta and Gozo published by the Government of Malta.

5. Borġ in-Nadur. 574656. C. Outside the famous Bronze Age defensive wall, and just beyond a modern field wall, a pair of ruts heads out onto the promontory. It appears to be making for a point where the fortification turns in beside the D-shaped bastion. This would be the most likely place for an original entrance, though now obscured by tumbled rubble. It provides one of the best examples of ruts approaching a Bronze Age settlement.
See also p.13 and nos. 43 and 47.

D. A second pair crosses the footpath which climbs the north flank of the ridge from beside the boat park. It is not clear how these two relate to each other, or to the Għar Dalam and St George's Bay sets.

6. Wied Ħas-Saptan. 558660. D. A pair follow the north side of the valley.

7. L'Imsaqqfa, Gudja. 553683 (Gravino co-ordinates). **A**. This pair cannot now be traced. It is shown in an old photograph in the series on Maltese field antiquities taken by L. Gravino in c.1947, see p.21.

8. Ħaġar Qim. 494652. B. There are traces of a single pair on the north side of the path from Ħaġar Qim down to the Mnajdra Temples, and slightly nearer the latter. It should be stressed that they show no sign of connecting with either temple, their proximity being purely coincidental.

A short stretch of rut beside the path between the Neolithic temples of Ħaġar Qim and Mnajdra does not apparently connect with either.

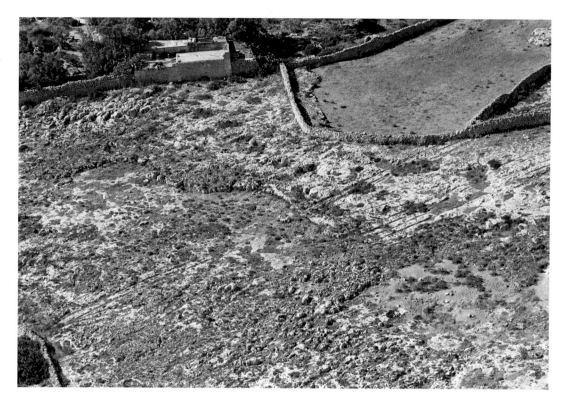

Clear sets cross bare rock near the Laferla Cross.

Opposite page: This ancient rut is behaving exactly like the present road following the Dingli cliffs.

Categories:

A
level ground

B
up and down slope

C
 ridge crest

D
side of ridge

E
crossing ridge

F
down spur

G
round spur

H
lip of cliff

I
beside or into sea

9. Laferla Cross. 472674. A. A stretch of ruts extends southwards from this San Lawrenz Chapel chapel near the Laferla Cross Near the Laferla Cross, a stretch of ruts extends southwards from the San Lawrenz Chapel towards Gebel Ciantar. One pair runs out onto an expanse of bare rock getting gradually shallower until it fades out altogether. This strongly suggests a former soil cover, now eroded away. Similar evidence will be quoted at no. 32.

10. Ġebel Ciantar. 465667. A. Scanty traces, probably once linking with nos. 6 and 8, occur across this tableland, with extensive views to the sea to the south now partly obscured by quarrying.

11. Fawwara. 460668. H. A dramatically sited former Bronze Age village at Wardija San Ġorġ is approached by a pair of ruts along the top of the cliff above the Fawwara spring, though it disappears under terraced fields before reaching it.

12. Ta Żuta. 457671. H. Ruts run along the verge of the present road at the point where the rough lane descends to the Wardija San Ġorġ. They do not connect with it, see p.14/15.

13. Dingli Cliffs. 446678. B/H. A pair drops down the slope to the east of the Maddalena Chapel beside the cliff top road. It joins another pair crossing the road but not further visible in the fields to the north. At one point, the main pair cuts through a shelf of rock at 45°.

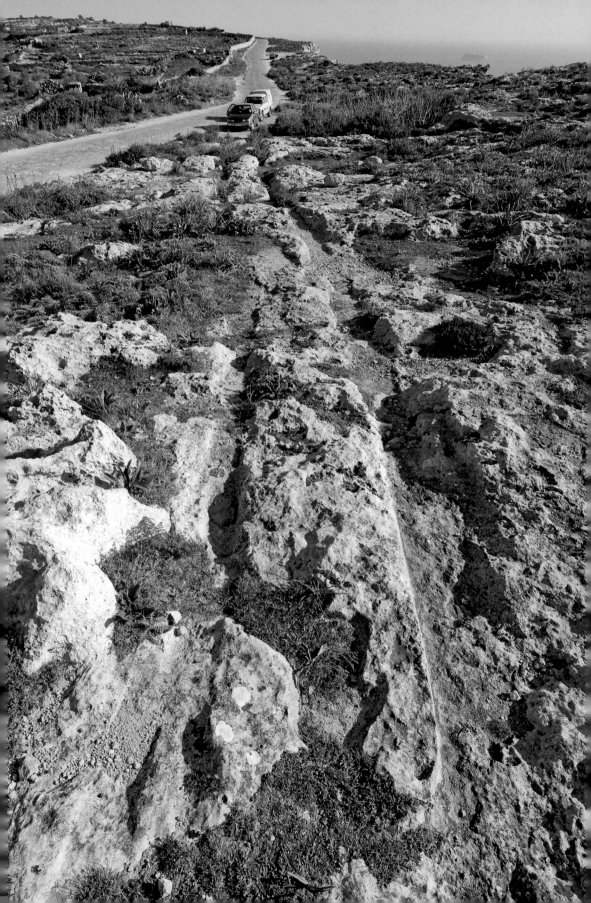

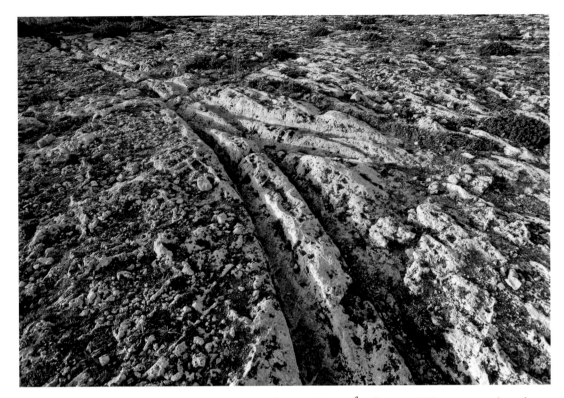

Clapham Junction. Ruts forking like this explain why the group beyond Buskett came to be named after the London railway junction.

Categories:

A
level ground
B
up and down slope
C
ridge crest
D
side of ridge
E
crossing ridge
F
down spur
G
round spur
H
lip of cliff
I
beside or into sea

14. Clapham Junction, Buskett. 456678 focal point, 300m east, south and west. **E.** The most extensive rut system in the islands by far. While it is difficult to calculate the exact number, at least 30 fan out on a narrow front where they emerge from fields on the northern, Buskett, side. They then climb the slope, forking frequently, though now partly covered by an isolated field. They pick up again on the south side, dropping towards a shallower valley, again disappearing under fields. Any further extension has now been cut away by active quarrying with more beyond. To the east, a set runs into, and stops at, an ancient quarry.

C. In addition, a single pair follows the crest of the ridge, cutting across all the others. Towards the west it is interrupted by the northern lip of Għar il Kbir, which is worth a visit in its own right. The rock collapse here probably occurred at, or shortly after, the residents of these caves were forcibly removed down to Siġġiewi village in 1835. On the east side of the cave, the nearest rut is cut by the square shaft of a Punic tomb, as at nos.18 and 20. The neatness of the cut shows unmistakably that this rut at least was older than this tomb.

The group as a whole underlines the scale of the problem set by the Maltese cart-ruts. Any explanation has to take account of their quite extraordinary multiplicity here.

15. Verdala. 462692. A. A single pair can be made out beside the road which descends on the north side of the Verdala Palace towards Siġġiewi.

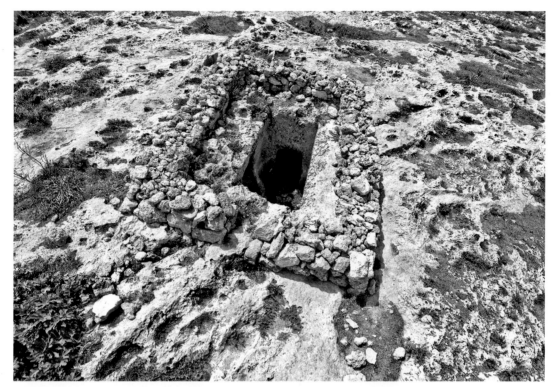

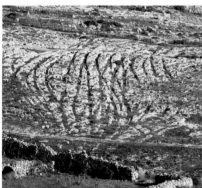

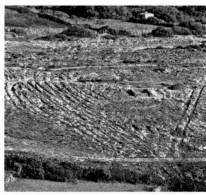

A pair running from top right to bottom left was cut through by the shaft of a Punic or Roman tomb above Għar il-Kbir, Clapham Junction.

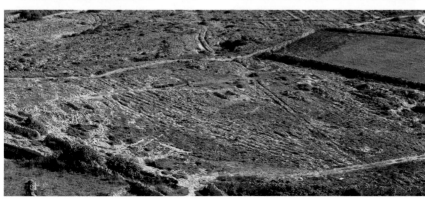

Left and overleaf: Three general views from the air reveal the complexity and multiplicity of this site.

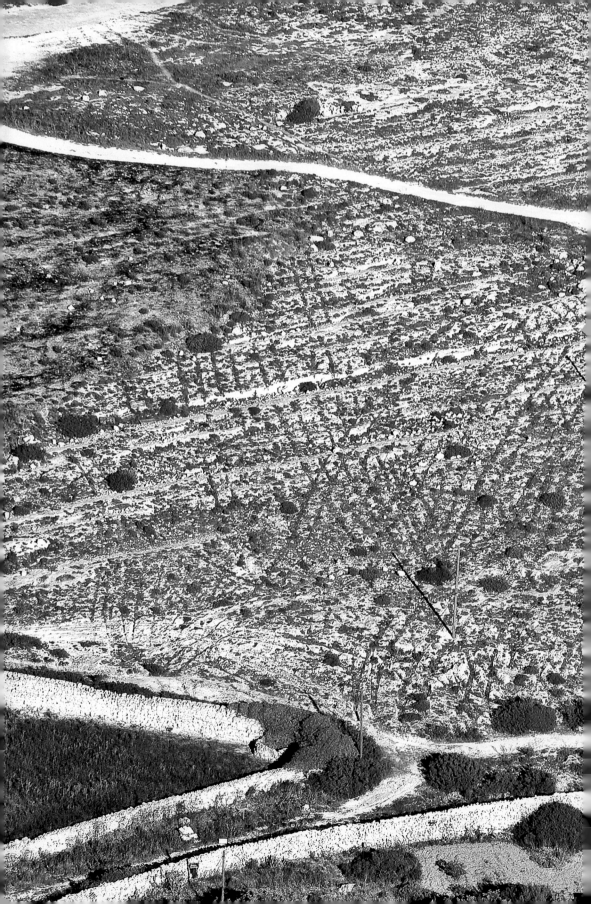

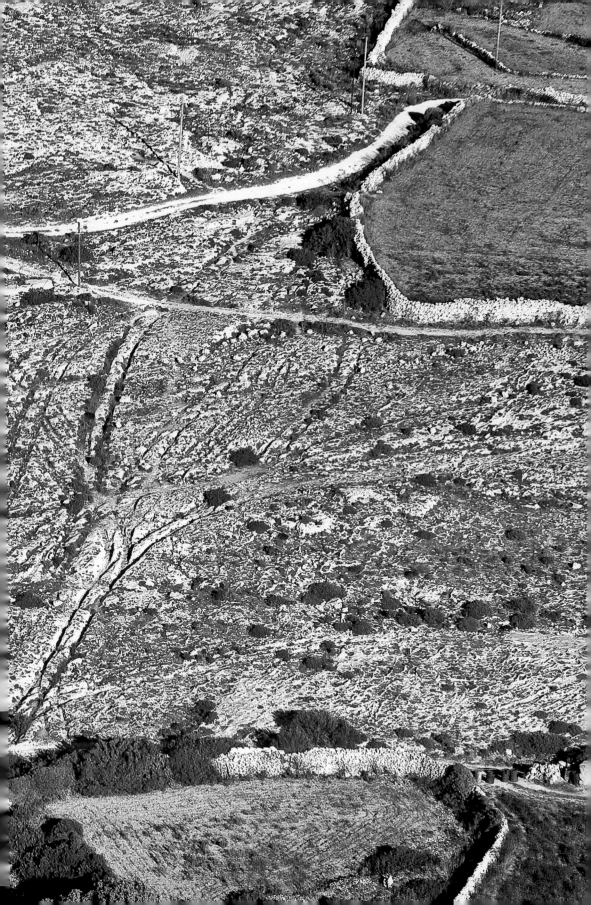

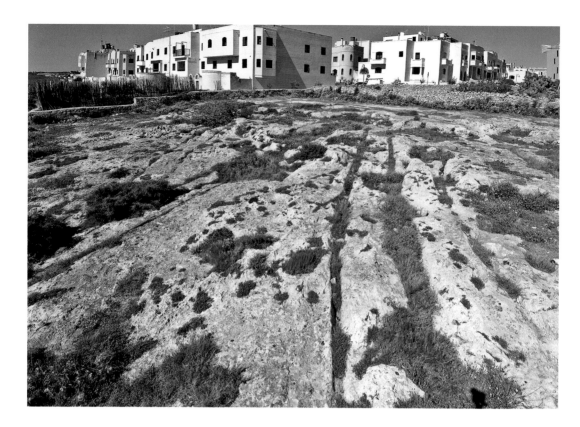

Three rut groups at Mtarfa (top), Qallilija (opposite, top) and Madonna tal- Lettera (opposite bottom).

Categories:

A
level ground

B
up and down slope

C
ridge crest

D
side of ridge

E
crossing ridge

F
down spur

G
round spur

H
lip of cliff

I
beside or into sea

16. Tat-Tarġa, Rabat. 444710 centre. **A/G.** One pair follows the lip of the plateau north of the Lunżjata Chapel. A second joins it over level ground from the north-east.

17. Domus Romana. 458716. A. A pair can be seen behind the Domus Romana, aiming for the valley to the west. It follows the curve of a wall, so this one at least must date to the Roman period, see p.18.

18. Mtarfa. 453720. A. Several ruts cross bare rock to the south-west of the former hospital. One is again clearly cut by a Punic tomb. It is worth noting that Bronze Age silo pits were found towards the tip of the Mtarfa ridge, suggesting a former village of that date.

19. Qalillija, Wied l'Armla. 442727-445726. B/D. The rocky ridge east of the Tas-Salib chapel has a number of ruts running out onto it. Near the road, after surmounting another 45° step, it crosses it, to be sliced through by a lane to the west. It then swings north to join the next group.

20. Madonna tal Lettera. 439736. A,B. One of the most dramatic pairs crosses a second south east of the chapel, towards the crossroads, where they run on to no.21. In the other direction they dip into the valley over the scarp of the Victoria Lines towards the hamlet of Binġemma, with magnificent views over the village of Mġarr and an extensive sweep of north Malta and Gozo.

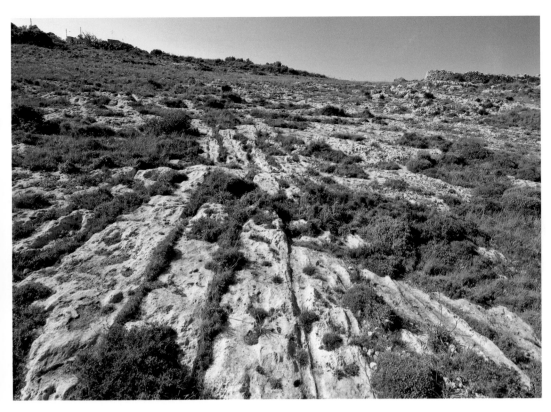

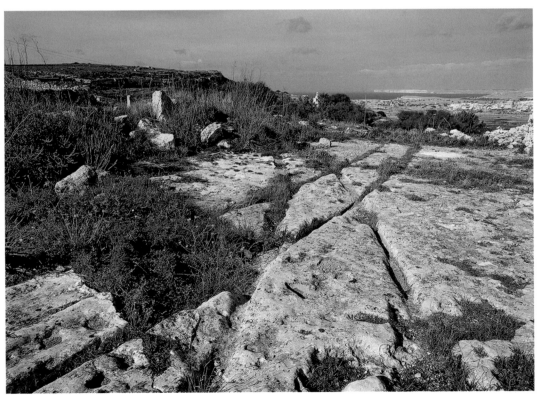

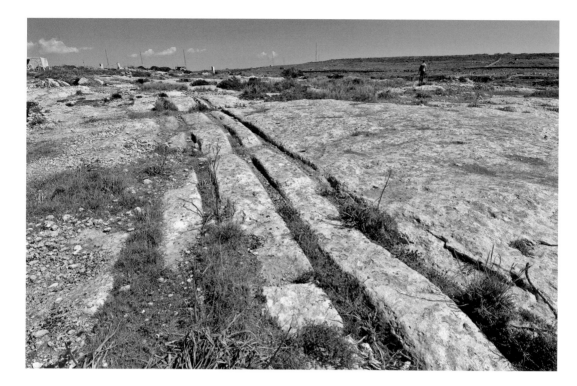

A duplicated track on the slope above Wied Rini, Baħrija.

21. Binġemma ridge. 439732 centre. **A, B.** Groups run in several directions to the west of the road, some swinging south to join no.19, others north to 21 and north-west to 22. There are several square Punic tomb shafts here, one of which cuts through a rut. Until recently, more ruts ran parallel to the road on the east, but these have now disappeared under dumping.

22. Nadur Tower. 438733-434734. A, C. Numerous ruts follow the ridge either side of the road here, connecting with no.21 but disappearing westwards.

Categories:

A
level ground
B
up and down slope
C
ridge crest
D
side of ridge
E
crossing ridge
F
down spur
G
round spur
H
lip of cliff
I
beside or into sea

23. Ta' San Ġakbu (Għar Żerrieq). 425705-423708. A, H. Where the lane runs out to the cliff lip, ruts follow the latter for some distance. Though clearer to the right, the most interesting is a short distance to the left. Here a pair runs clean over the lip. They can be seen again on a block which has cracked off but not yet slipped down the slope below, explaining the phenomenon - flaking of the cliff lip. Compare also no.49.

24. Mtaħleb road. 425712. D. Just after the Fiddien-Mtaħleb road climbs away from the Wied Busbies, by the San Ġakbu turn, a pair of ruts crosses it.

25. Tal Merħla. 407715. A/D. Confusingly, the place-name ('of the flocks') refers to both the hilltop above and the hamlet below the cliffs west of Mtaħleb. A kilometre beyond where the cliffs turn north, a rut follows close beside the latter.

26. Wied Rini. 412722. B, F. On the spur between valleys south of Baħrija village, multiple ruts run down the spur, while others cross it.

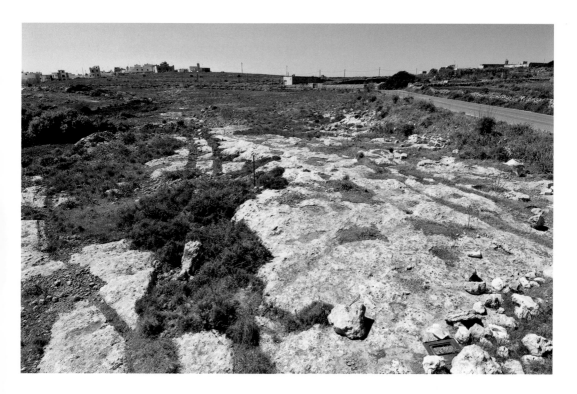

27. Baħrija. 420726-405730. A. A 2 km length of rut can be followed, admittedly with some gaps, from near the turn to the Wied Rini radio station to a point midway between San Martin church and the great Bronze Age village on Il Qlejgħa. At first it runs south of the San Martin road, but then crosses it twice. It forks into several pairs in the open space in Baħrija village, though much of this group is now covered in tarmac, including the pair which not so long ago ran straight into the front door of a bar. Beyond the village, they fan out over bare rock to the north west, one pair terminating at an ancient quarry.

Also near Baħrija, ruts beside a modern road.

28. Tarġa Battery. 469750. H. A good pair follows the road beside the Victoria Lines just east of the battery, a continuation of the western pair at no.29.

29. Tarġa Gap. 471753. B. Within the hairpin and just beside the statue of St. Joseph, two pairs of ruts climb steeply up the slope, though their junction is not visible. One pair heads west towards no.28, one east towards 30.

30. Misraħ Għonoq. 475753. H. Just above the Lines like no.28, a pair is heading for the promontory between the scarp and the Wied il Għasel, now occupied by Fort Mosta. That too once held a Bronze age settlement.

31. Fort Mosta. 484758. B. A pair emerges from the east side of the fort to run down the slope though it soon disappears. Presumably it once linked nos.30 and 32.

Overleaf:
Ruts follow the cliff lip at San Ġakbu.
One at bottom right is being carried away by cliff falls.
Recent ruts, top rut, show the wear caused by the hooves of the animal drawing the cart.

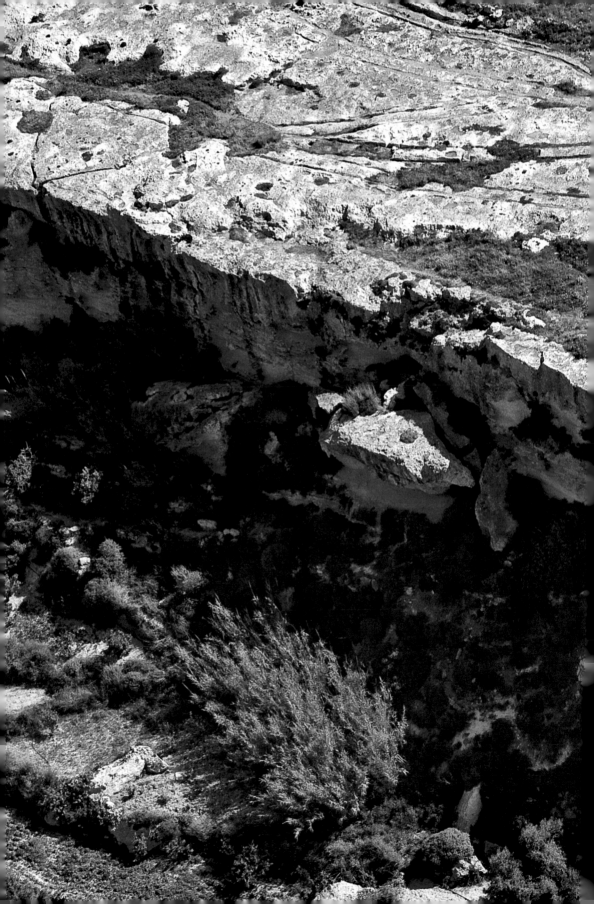

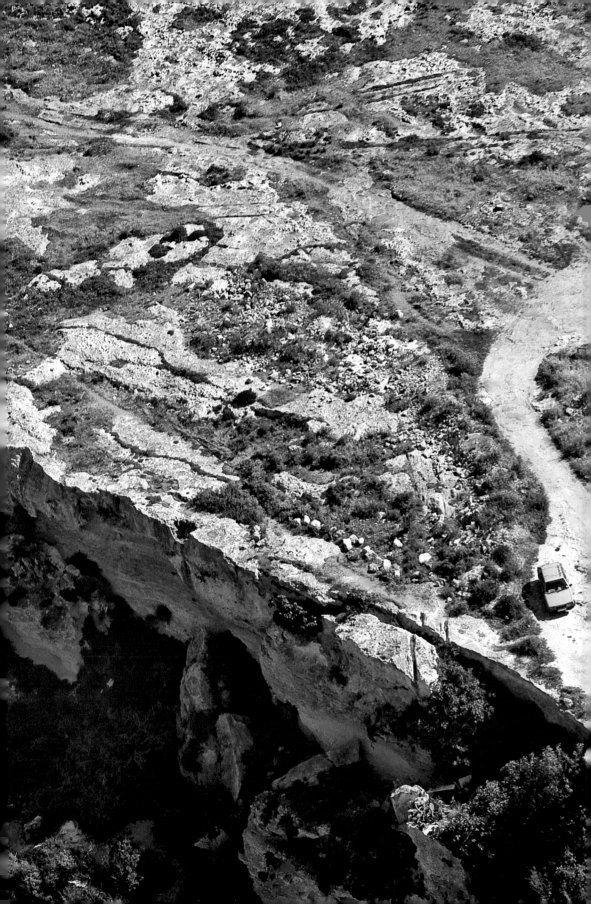

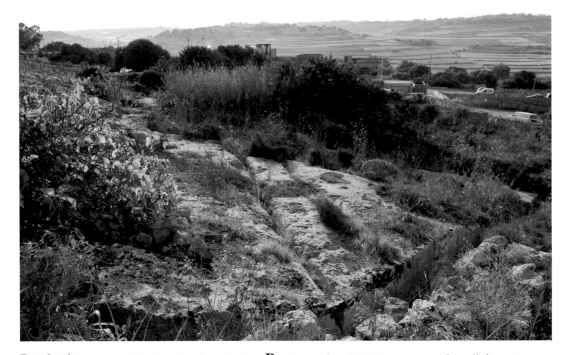

Top: A pair approaches the Tarġa Gap. (see p. 33)

Opposite page: The complex group descending the slope at San Pawl tat-Tarġa.

Overleaf: Details from San Pawl tat-Tarġa

Categories:

A
level ground

B
up and down slope

C
ridge crest

D
side of ridge

E
crossing ridge

F
down spur

G
round spur

H
lip of cliff

I
beside or into sea

32. San Pawl tat-Tarġa. B. Centred at **494760** ruts extend in all directions. Although less numerous than the Clapham Junction group, these are surely the most interesting, and deserve exploring in every detail. At the simplest, they connect the high ground north-west of Naxxar village with the lower ground below the Victoria Lines and the Great Fault. Much of the upper area is now built over, but the expanse of rock below the Mosta road has been kept clear, though nibbled at by the quarries at its western end.

Just west of the WWII pillbox, the main group forks. One branch swings sharply back to the east by what can only be called a hairpin to head in the direction of the coast at Baħar iċ-Ċagħaq, though they can be traced for only a short distance beyond the road. The other continues westwards down the ridge, to disappear under fields towards St Catherine's chapel. See also nos.33 and perhaps 31.

The hairpin itself is worth inspection. Other details include the following. At one point, a rut reaches a depth of 60 cm, rivalling the deepest on the islands. At another, a side channel has been cut to drain rain water caught by the rut into a cistern to receive it. However, as explained in the main text, this is clearly a secondary feature. Water has collected in other lesser dips, where it has stood long enough to etch the rock surface slightly. Again this is incidental and no explanation of the way the ruts formed. A very significant point is in the rut inside the hairpin, which bumps into and out of a previously eroded hollow in the rock, discussed on p. 20. There is a fine example higher on the slope of what I have called a 'lurch', where one rut has worn much deeper than the other of the same pair. Minor steps occur, though none here so steep as those noted at some other sites.

All in all, one can spend an hour or two happily exploring, and pondering on, the problems set by this group.

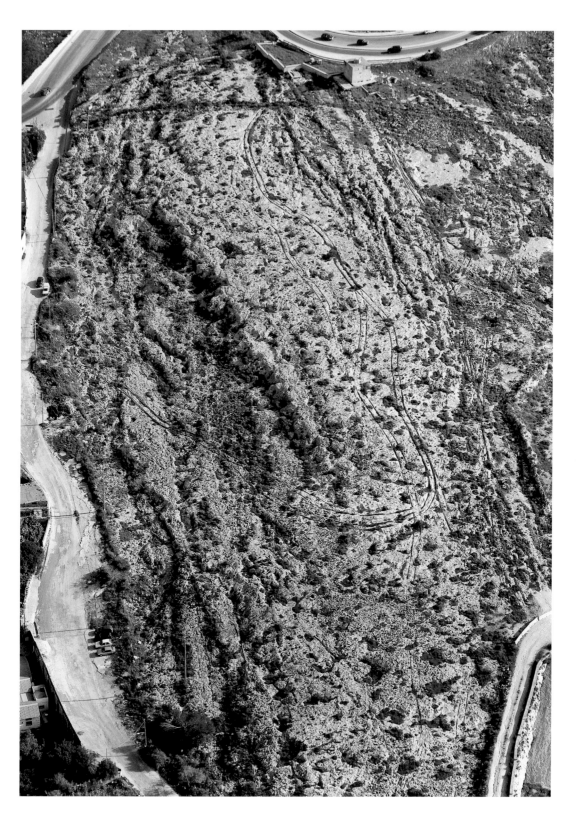

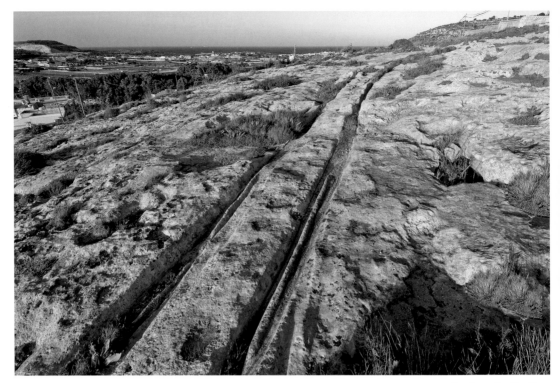

A minor duplication.

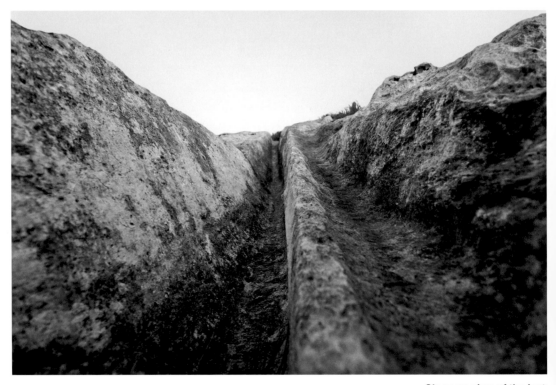

Close up view of the last.

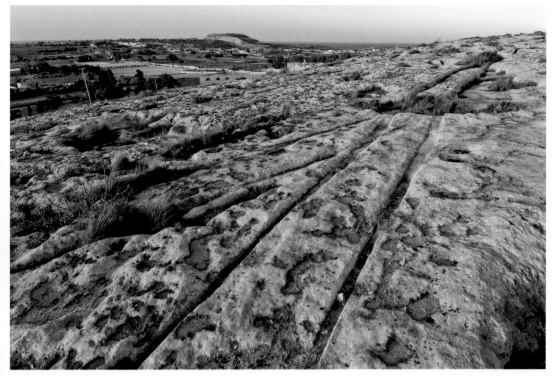

A fork, again over irregular rock.

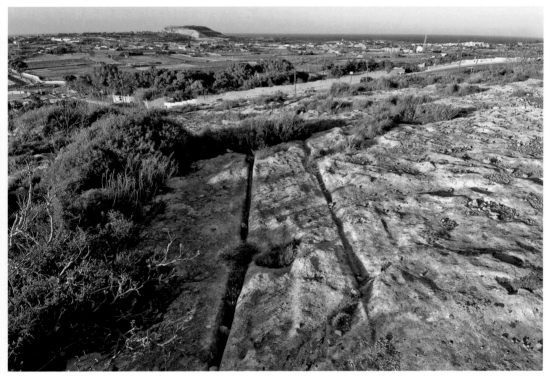

Heading down the slope towards Burmarrad.

The duplicated pair beside the Salina catacombs.

33. Tal Qadi. 485767-477777. D. At several points along the eastern edge of the Burmarrad basin, one long and several short stretches of rut survive. Their significance can really be appreciated only from the air, when it becomes apparent that they are all part of a single rut system which connects the San Pawl and Salini groups, nos.32 and 35. The total length, end to end, would then be at least 4km, connecting the high ground with the sea, see p.12.

34. Salini catacombs. 482782. B. A short length but partly doubled runs down the slope just beyond the catacombs north of the Annunziata chapel. It is at right angles to groups 33 and 35.

35. Salini fougasse. 483786. I. This pair runs parallel to the shore and coast road just beyond the fougasse. It is presumably a continuation of no.33. Both the catacombs and the fougasse (an 18th century rock-cut cannon) are antiquities of great interest too, but they are another story, or rather two other stories.

36. Ġebel Għawżara. 464765. A. Curving, but trending east-west, a pair can be seen just south of the lane junction.

37. Ħal Dragu. Bidnija. 453760. C. A multiple set, including a junction, lies just north of the road here, with another double pair a short distance to the south. A further pair follows the same line 200 m to the east.

Categories:

A
level ground

B
up and down slope

C
ridge crest

D
side of ridge

E
crossing ridge

F
down spur

G
round spur

H
lip of cliff

I
beside or into sea

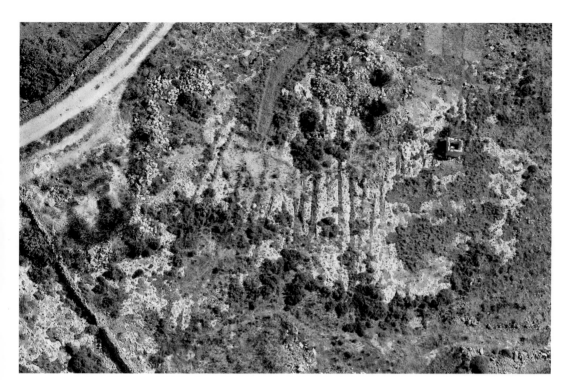

38. Żebbiegħ 1. 445757. D. Having slipped off the ridge, it is probably the same run as no.37.

39. Żebbiegħ 2. 443757. E. This pair comes over a slight ridge from the north-north-west.

40. Żebbiegħ 3. 441757. C. At least eight parallel pairs run up to the Bidnija road from the south-west.

41. Żebbiegħ 4. 441755. E. A pair of ruts was visible here until recently, but has now vanished under tarmac. Skorba Temple is 100m off to one side.'

42. Wardija 1. 455774. C, E. Two pairs cross at right angles, along the ridge and over it.

43. Wardija 2. 451772. C, E. Here there is another crossing pair like the last.

44. Wardija 3. 448767. H. A 300m length runs between the road and the cliff lip.

45. Zamitello. 424758. E. A pair crosses the ridge north of the Zamitello Palace, north-west of Mġarr village.

> At least eight pairs of ruts cross level rock at Żebbiegħ 3.

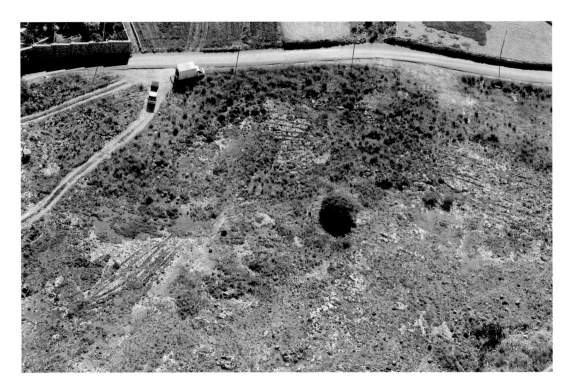

A group approaches the ridge at San Martin beside the present road, with another swinging in to join it.

46. Qala Hill. 468773. C. Overlooking the San Martin valley, this hilltop supported another Bronze Age village, with silo pits and traces of a defensive wall. A rut approaches it along the ridge from the west but then forks, one branch heading for each end of that wall, where there were presumably once entrances. Compare the situation at Borġ in-Nadur, no.5, and Ras il-Ġebel no.50.

47. San Martin. 437765. E. A modern road from Żebbiegħ to the Pwales valley follows closely a set of ruts taking an almost identical course. They are best seen crossing the road by the pumping station, heading for the saddle over the ridge beyond. They disappear under dumping before reaching the cave sanctuary of the Madonna ta' Lourdes, which has lost any prehistoric occupation deposit it may once have had.

48. Ta' Mrejnu. 431763. A. Just south of the Żebbiegħ-Għajn Tuffieħa road, ruts run west from the Mġarr road, with further traces under the pinewood to its west beyond.

49. Il Palma. 429766. E. Another pair, much mutilated by quarrying, had used the next gap through the Wardija Ridge.

50. Ras il-Ġebel. 420765. C. The western end of the Wardija Ridge, like Qala Hill 2 km to the east, also had a wall, of which scanty traces survive, cutting off a Bronze Age settlement. Here a single pair of ruts runs toward it.

Categories:
A
level ground
B
up and down slope
C
ridge crest
D
side of ridge
E
crossing ridge
F
down spur
G
round spur
H
lip of cliff
I
beside or into sea

THE CART-RUTS

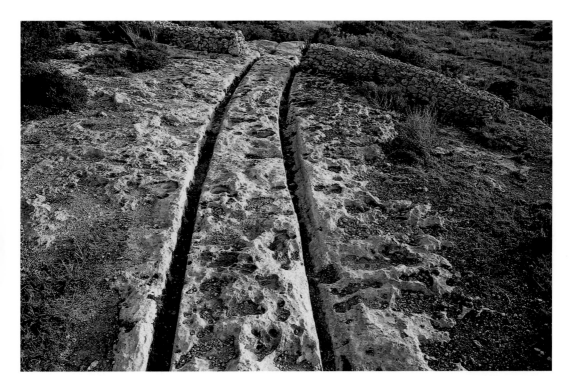

51. Qala il-Pellegrin. Best seen at **403750. H**. The whole of this spectacular plateau is encircled by a pair of ruts. This is clearest on the western, seaward, side, except where cliff falls have removed a 100m section. It is straddled by a Roman site, with a big cistern, just to north of this, and goes nowhere near a temple-period structure near the centre of the plateau. The rut is of a different period from either of these.

52. Xemxija. 445788. Bajda Ridge has many groups of ruts, the first four probably part of a single system, well over a kilometre long, but for convenience here treated separately.
C, D. A pair crosses the ridge, partly destroyed by Prehistory Street and the houses on its east side, well-named though showing scant respect for the prehistory. It then slants down the slope to the west. A branch forks eastwards along the north flank of the hill, recently cleared of soil and vegetation.

53. Mistra. 434785. D. Occasional traces to the west connect with a six-fold group near the foot of the slope. The name, applying to the whole valley, is admittedly somewhat misleading, but the map does not offer a more specific one.

54. Miżieb road. 433784. E. The modern road is cut into the rock. Immediately above this, a fine pair appears to connect group 53 with the pass back to Pwales, though it loses itself in the pine woods before reaching the crest.

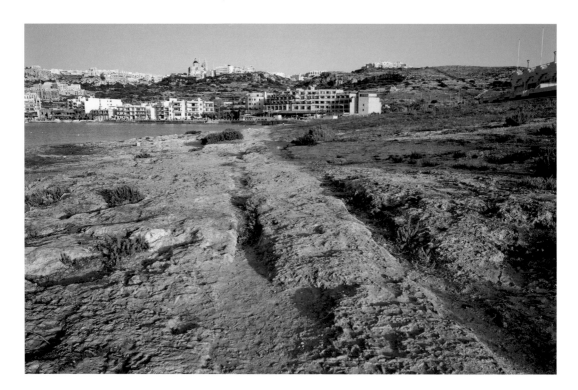

Ruts on the foreshore of Mellieħa Bay.

55. L-Imbordin. 435783. D, H. The scarp flanking the Pwales rift on the west of the road has two pairs of ruts. The upper runs out to the lip of the cliff and stops, though there is no sign of rock flaking here as at nos.23 and 51. Immediately below is a cave mouth, so perhaps loads were lowered to this by rope. The second runs out onto a shelf down the slope, which pinches out at another cave mouth. Unfortunately, neither cave has ancient deposits surviving, or they might have given us the date of the ruts which we so badly need.

56. Manikata. 425788 to 415787. D, E. Ruts follow the side of the ridge for nearly a kilometre, while shortly beyond the church, others cross it exactly as the modern road does. Another forks off to the north-east at 423782

57. In-Naħħalija, Ras il-Waħx, (though 800m east). **405778. E.** A prominent saddle at the west end of the Bajda Ridge has another pair of ruts crossing it.

58. San Niklaw. 415797. B. A pair close to the present road descends the slope in the same way, perhaps to link with 59. One branch swings uphill to the south, two others cross the side valley to the south west.

59. Mellieħa Bay. 416807. I. This pair skirts the shore, though does not dip into the sea.

Categories:

A
level ground

B
up and down slope

C
ridge crest

D
side of ridge

E
crossing ridge

F
down spur

G
round spur

H
lip of cliff

I
beside or into sea

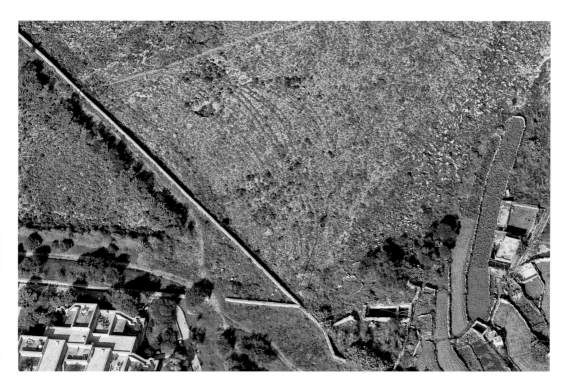

60. Għadira. 411809. G. On the south side of the nature reserve, a multiple group of ruts swings round a ridge projecting from the higher ground of Biskra.

61. Biskra east. 409805. E. From the last, a rut curves off to the south-west, heading over to the next valley.

62. Biskra west. 405804. E. A second does much the same over the next saddle, 400m further west, disappearing immediately above Popeye Village.

CAT-RUTS IN GOZO

63. Tan-Nemes, Qala. 396878. C. Near the eastern tip of Gozo, a ridge projecting to the south-east has a fine pair of ruts on it. They run out along the ridge, but then slip off it on the north side before vanishing.

64. Qortin. 374904. C. The north-eastern projection of the Nadur plateau has a rut following its crest. Its eastern end is inaccessible in an army camp, but it can be traced for 200m or so towards the west. On the next ridge 800m to the south, another pair was formerly visible, now vanished under development. Two others are said to have existed on the outskirts of Nadur village.

65. Ta' Lambert. 345872. A. A small group is to be found at a lane junction just south of the former heliport.

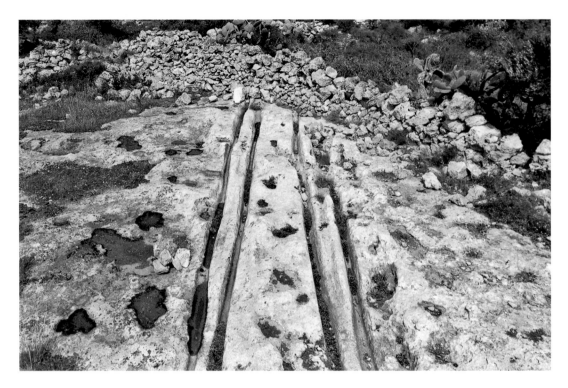

The lower set at Ta'-Tinġi, Xewkija.

66. Ta' Tinġi. Xewkija. 330876. D. Two sets, 150m apart and roughly parallel, run along the slope through an olive grove immediately west of the pumping station south of Xewkija village. This is one of the best groups on Gozo, including a deep stretch, doubled, and a junction

67. Ta' Ċenċ. Here considered three groups, though interconnected. The best is near the cliff lip south of the Ta' Ċenċ Palace Hotel. **326865. A, H.** It disappears under a field wall to the west, and to the east swings inland to join up with the next.

68. Borġ l-Imramma. 330866. A. Various ruts cross the open rock on the Ta' Ċenċ plateau immediately south of the megalithic courtyard of this name. They nowhere run to it, nor anywhere near the Bronze Age dolmens on the northern lip of the plateau.

69. Wied Sabbar. 336864. B. One pair runs 500m eastwards now stopping. on the lane overlooking Wied Sabbar and Mġarr ix-Xini.

70. Dwejra. 271904 centre. **B, H**. A worthy group with which to end our list. Less extensive than San Pawl tat-Tarġa, no.30, this group is almost as interesting, and set in and overlooking spectacular scenery on Gozo's west coast. Starting by the quarries south-west of San Lawrenz, it runs down the steep slope above the Inland Sea, joining a second pair on its west 4m short of a ruined structure, perhaps once a Roman round tower, it swings sharply to the right in what is in effect another hairpin, and forks again, here at its deepest.

Categories:

A
level ground

B
up and down slope

C
ridge crest

D
side of ridge

E
crossing ridge

F
down spur

G
round spur

H
lip of cliff

J
beside or into sea

THE CART-RUTS

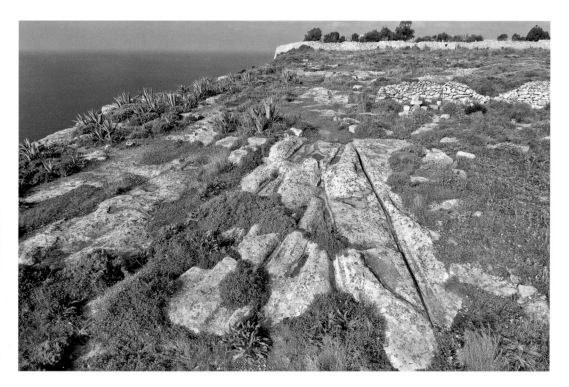

The next stretch is very faint, but picks up again, presumably after another hairpin, to bend back to the south-east. After an even sharper bend, with a radius of only 5m., it turns west where there is a 'lurch'. There it now vanishes over rough and eroded rock, but probably once turned down the slope in yet another hairpin to give access to the Inland Sea or the open sea to the west. Before this rut vanishes there is a 'lurch' even more marked than that at San Pawl tat-Tarġa No. 32.

Top: Ruts running beside the lip of the Ta' Ċenċ cliffs.

Bottom: Just above the inland Sea, Dwejra.

Other groups not listed here have apparently been obliterated since first recorded, one in Xewkija village, one just north of Xagħra and two in Nadur. Back in Malta, earlier reports mention two examples under Pawla, and others just outside the main gates of Valletta and Mdina. The last certainly had Bronze Age remains beneath it. Doubtless there were once many more, and even further surviving pairs may still have escaped notice. In consequence, this catalogue must be regarded as provisional only.

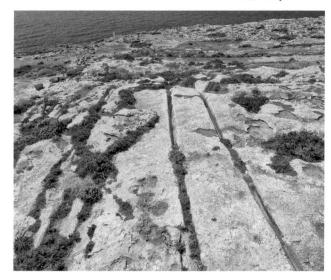

FURTHER READING

Bonanno A. 2005. *Malta: Phoenician, Punic and Roman*, pp. 338-40. Malta: Midsea Books.

Evans J.D. 1971. *The Prehistoric Antiquities of the Maltese Islands*, pp. 202-4. London: Athlone Press.

Gracie H.S. 1954. The ancient cart-traks of Malta. *Antiquity* 28, pp.91-8.

Hughes, K.J. 1999. 'Persistent features from a palaeo-landscape: the ancient tracks of the Maltese Islands', *Geographical Journal*, 165 no. 1, March 1999, pp. 62-78.

Trump D.H. 2002. *Malta: Prehistory and Temples*, pp. 280-5. Malta: Midsea Books.

Trump D.H. 2004. 'The enigma of the cart-ruts', in Cilia D. (ed.), *Malta Before History*, pp. 379-98. Malta: Miranda Publishers.

Ventura F., T. Tanti 1994. 'The cart-tracks at San Pawl tat-Targa', *Melita Historica*, xi (3), pp. 219-40.

Zammit T. 1928. 'Prehistoric cart-tracks in Malta', *Antiquity* 2, 18-23.

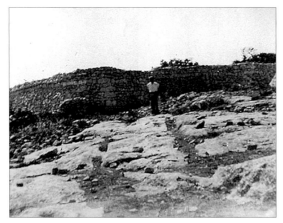

A pair of cart-ruts at tal-Borg, looking west.
It is hard to state whether these ruts
kept going, or terminated here, since field-soil covers
every bit of rock at this end. These ruts are now entirely
covered up as the ground has been levelled for traffic purposes.

Entry in one of two photo albums compiled in 1969 by Mr Laurie Gravino. The albums contain more than 200 photographs and drawings of many prehistoric sites. The photography was done by him and Mr Publius Farrugia between 1945 and 1948.
Unfortunately we do not know which tal-Borġ (many areas in Malta and Gozo are refered as tal-Borġ) is Mr Gravino referring to here.